Experience
OREGON

THE OREGON
HISTORICAL
SOCIETY
FOUNDED 1898

SCALA

EXPERIENCE OREGON

Visitors of all ages, and from all parts of the world, come to the Oregon Historical Society (OHS) each year to learn about Oregon. From its varied geography to its innovative legislation, Oregon is complex and distinctive, filled with people whose stories are the foundation of the state we see today. Whether you were born here, have chosen to make it your home, or are just passing through, it is undeniable that there is something special about Oregon.

For more than a century, OHS has served as our state's collective memory, gathering and preserving a vast collection of objects, photographs, films, manuscripts, books, and oral histories. Hundreds of these items are on view in OHS's permanent exhibition, *Experience Oregon*, an award-winning educational space where visitors can learn about the people, places, and events that have shaped Oregon from time immemorial to today. By making connections across time through broad themes, such as home, movement, and water, the exhibit highlights the diversity of Oregon's geography as well as people's historical and ongoing relationships with the land and with each other.

Those themes draw connections to the important conversations of today — both challenging and triumphant. It is our hope that those who visit *Experience Oregon*, and those who read this accompanying book, will leave with a better understanding of the many ways our past connects with our present — emphasizing why learning about history matters.

KERRY TYMCHUK
Executive Director
Oregon Historical Society

➤
Sam Lee, "The Clam Digger," ca. 1910. Sam Lee, who moved to Seaside, Oregon, in the late nineteenth century, often sold clams door-to-door. The popular Hotel Moore once sat on the Seaside "Prom" (promenade). *OHS Research Library, photo file 238-A*

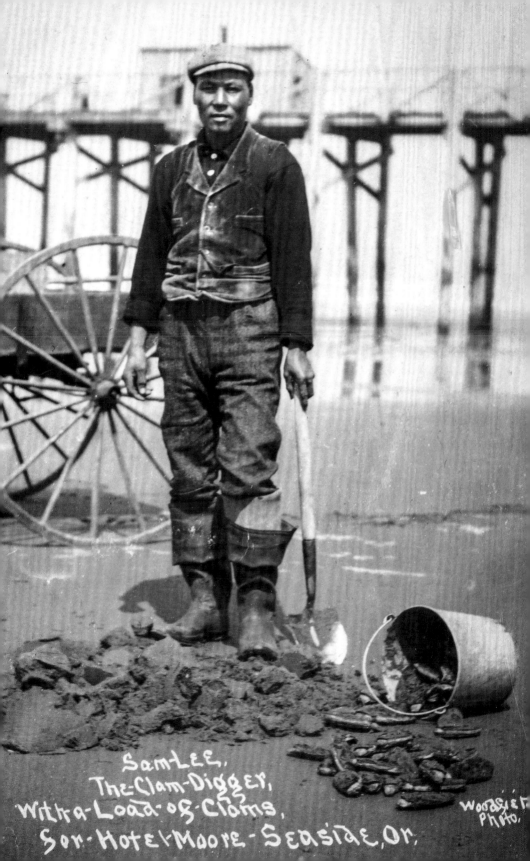

Sam Lee,
The Clam-Digger,
With a Load of Clams,
For Hotel Moore Seaside, Or.

Woodfield
Photo.

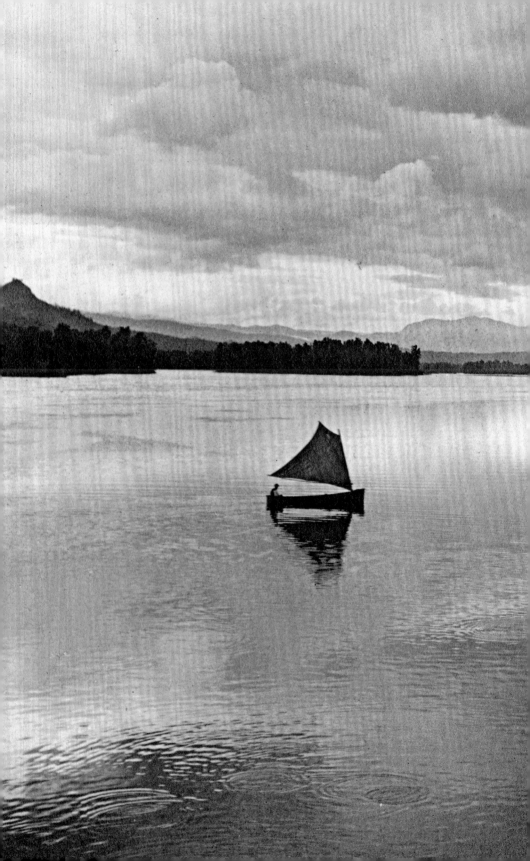

OREGON HISTORY AT A GLANCE

By the time the word *Oregon* appeared on a map in the late eighteenth century, no known world explorer had yet determined the topography of the Pacific Northwest, even though much of the world had been colonized, claimed, and examined. Hemmed in by the Pacific Ocean to the west, Mexican territory to the south, and European nations on every other side, the chunk of North America that would become the Oregon Country was of intense interest to the world, not only because it might have valuable resources but also because it might hold the key to a near-mythical water passage that cut through the continent. Many seafaring nations wanted that waterway to be real, and they sent ships to find the mouth of what they called the Northwest Passage.

Meriwether Lewis and William Clark finally dispelled the myth of a cross-continental waterway in 1806. What they reported — rivers rich with fish and fur-bearing animals, a temperate climate, a diverse ecosystem, and thousands of Native people willing to trade — stimulated an expansion of the fur trade to the Rocky Mountains. The Oregon Country had been "found," and Indigenous economies and land management systems that had been developed over millennia were reconfigured.

By 1859, when Oregon became the thirty-third state, it had shrunk from its lankier form — once bounded by Alaska and stretching east into present-day Idaho and Montana — to the boxy shape it is now, made more interesting by the shorelines of the Pacific Ocean and the Columbia and Snake rivers. The state was created in disregard of tribal sovereignty and in the shadow of slavery, by a U.S. Congress on the brink of war. Its distance from the eastern United States did not immunize white settlers from adopting the worst impulses of a nation built on racial hierarchies. Oregonians still live with those founding inequities; 1859 is not so very long ago.

The region's natural characteristics — its large rivers, distinctive mountain ranges, and millions of acres of forests and ocean shores — have dominated Oregon's economy and social structures. Oregonians still startle when Mount Hood looms on a clear day or a herd of wild horses races across the High Desert. It is that impulse, shared with the region's earliest inhabitants and the people who followed, that also informs *Experience Oregon*.

AMY E. PLATT
Digital History Manager
Oregon Historical Society

◀

Sailboat on the Columbia River, ca. 1902. *OHS Research Library, Org. Lot 140, b5, f29, photograph by Fred H. Kiser*

TAKE A WALK THROUGH OREGON

Ancient Oregon is visible on distinctive landscapes shaped by violent earthquakes, volcanic eruptions, and massive floods. Beginning at least 15,000 years ago, people witnessed some of those cataclysmic events and described them and the landmarks they created as part of an oral tradition that has been shared across generations.

In 1938, University of Oregon anthropologist Luther Cressman and his colleagues unearthed dozens of sandals in Fort Rock Cave, some made for children and some for adults. The sandals were made of shredded sagebrush bark with flat bottoms and flaps to protect the toes. The sagebrush was twined, or twisted, around wickerwork bent into U-shaped shoes. The Fort Rock sandals, and others found in the region, were carbon dated between 9,100 and 10,400 years ago, making them the oldest directly dated footwear in the world.

Fort Rock Cave sits a half mile west of Fort Rock, a volcanic tuff ring in the form of a circular "fort" that rises 200 feet from the plains of an ancient, dried lake in central Oregon. It is a striking formation. Remnant Ice Age lakes attracted animals and people to the area, many of whom witnessed the eruption of nearby Mount Mazama over 7,700 years ago.

➤
The opening to Fort Rock Cave, 1966, looking east toward Fort Rock in Oregon's High Desert. *OHS Research Library, photo file 434, photograph by Phil Brogan*

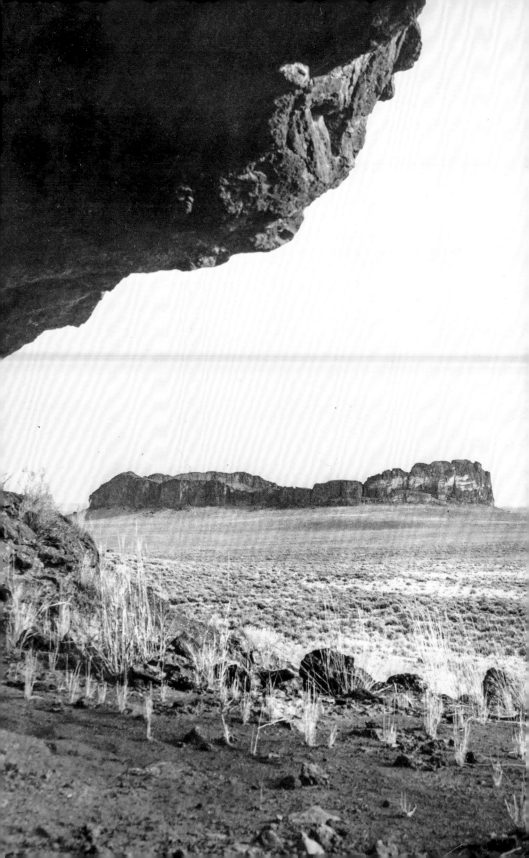

THE OREGON STORY

We know Oregon from the stories people have told about this place for thousands of years. Hundreds of tribes and bands lived here, speaking dozens of languages and following seasonal rounds for food, medicine, and building materials. When Euro-Americans colonized the region, they used Native knowledge and adopted traditional trade networks to chart riverways, roads, and towns. The fields Natives burned and cultivated were replanted as farmland, and the Indigenous fisheries and forests that were not destroyed by nineteenth-century settlement were appropriated by non-Natives.

Canoes — used for transportation, food gathering, and trade — were designed to handle Oregon's rivers and coastal waters. This canoe, built by the Scarborough family (Chinook) using traditional methods, was made to navigate the Pacific Ocean. The paddles were carved by the son of Hudson's Bay Company Captain James Scarborough and his Chinook wife Ann (Paley Temaikamae), daughter of Chief Concomly, a powerful headman in the lower Columbia region.

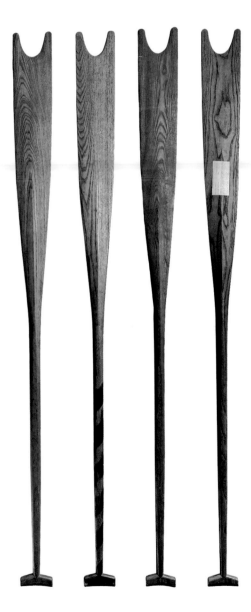

◀

Canoe, nineteenth century, made by the Scarborough family (Chinook) as an oceangoing vessel using traditional methods. Carvers shaped the hull to ensure symmetry on both sides from bow to stern. The canoe was then hollowed, and small, targeted fires were set inside the shell, which removed any excess wood. *OHS Museum, 780, photograph by Scott Rook*

➤

Paddles, nineteenth century. The distinctive crescent bottoms on Chinook paddles were ideal for snagging roots and rocks to navigate swiftly moving water. *OHS Museum, 779.1–.4*

SALMON PEOPLE

The Columbia River and its tributaries drain 259,000 square miles in seven states and one Canadian province, creating the world's largest anadromous fishery. River basins to the south — the Umpqua, Rogue, and Klamath — also have rich salmon fisheries. Indigenous people embraced the salmon's migration patterns and character into their worldviews and oral traditions. They honor the fish's significance as a food staple but also as part of the reciprocal relationships they have with the natural world, a fundamental belief that is passed down in stories and practices.

Salmon "determine future destinies," and the first catch of every fishing season is honored with a First Salmon Ceremony. Returning Pacific salmon migrate upstream, against the current, making magnificent leaps over falls and rapids.

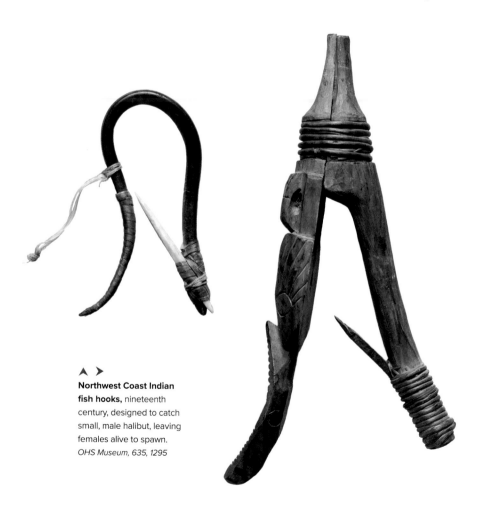

▲ ➤
Northwest Coast Indian fish hooks, nineteenth century, designed to catch small, male halibut, leaving females alive to spawn.
OHS Museum, 635, 1295

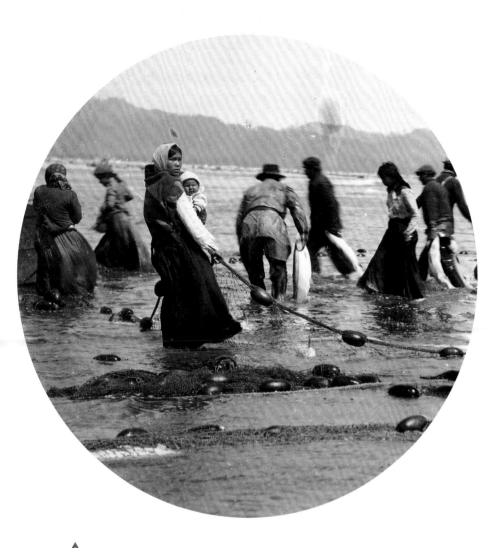

Chinook fishers, ca. 1905. These Native fishers, likely part of Chief George Charley's crew of Chehalis and Chinook, use a horse-drawn seine net near the mouth of the Columbia River on the shifting shores of Sand Island. *OHS Research Library, OrHi 46585, photograph by J.F. Ford*

Native fishers wielded dip nets and baskets to scoop up the fish below a fall or rapid and then handed them off for cleaning, pounding, and drying. Hooks made of wood, bone, and leather snagged fish such as halibut and sturgeon, and large weighted seine nets, lined with cedar so the edges floated, were dragged by horses or groups of people to catch schooled fish.

WHAT PEOPLE CARRIED

During the warmer seasons, people moved from permanent winter homes to temporary camps to hunt, gather, harvest, and trade. Seasonal rounds connected Indigenous peoples directly to the landscape.

For millennia, Natives have known where and when to find seeds and edible plants, fish, and game. Gathered crops included berries, camas, and wapato. Harvested materials for making baskets, clothing, and buildings included tules, willow, and cedar. Seasonal rounds were well planned and efficient, and people packed baskets, clothing, cooking and cultivation tools, and items for trade. Ceremonies and celebrations recognize the land as a living being and mark the changing seasons. Native people still practice seasonal rounds in Oregon.

◀

Parfleche, n.d. Designed for horse travel, it is an envelope-shaped carrier made of buffalo, deer, or cowhide that protected food, clothing, and other important supplies. *OHS Museum, 68-218, photograph by Scott Rook*

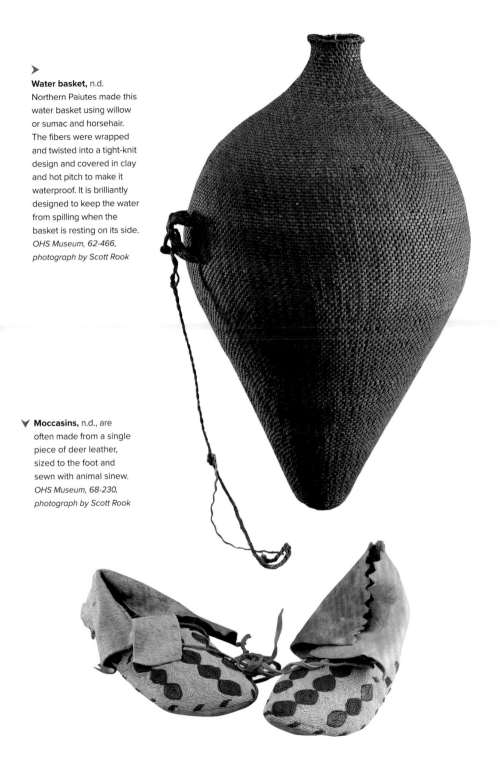

➤

Water basket, n.d. Northern Paiutes made this water basket using willow or sumac and horsehair. The fibers were wrapped and twisted into a tight-knit design and covered in clay and hot pitch to make it waterproof. It is brilliantly designed to keep the water from spilling when the basket is resting on its side. *OHS Museum, 62-466, photograph by Scott Rook*

▼ **Moccasins,** n.d., are often made from a single piece of deer leather, sized to the foot and sewn with animal sinew. *OHS Museum, 68-230, photograph by Scott Rook*

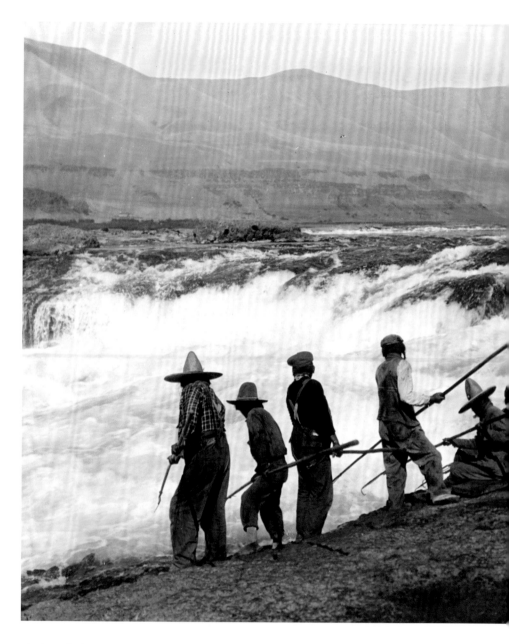

▲ **Spear fishing at Celilo Falls,** ca. 1900. Native fishers designed tools and nets to catch specific species of fish. Here, fishers stand upriver of Celilo Falls at *qíyakawas* (Gaffing Place) using hooked spears and dip nets to catch migrating fish as they cluster along the slower water near the riverbank. They were either fishing for their own use or sold their catch to canneries. In the distance is a fish wheel in Downes Channel owned by the Taffe family cannery. The salmon that escaped the spears and managed to jump the falls were likely to be scooped up by the spinning wheel upstream. *OHS Research Library, Org. Lot 982, photograph by Benjamin Gifford*

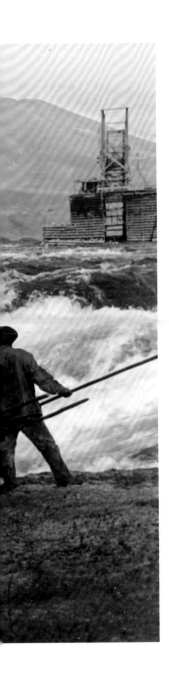

TRADE, TRAVEL, TERRITORY

People connected through seasonal movements and kinship networks, and they gathered to trade, gamble, and socialize at trading centers such as Celilo Falls and Willamette Falls.

Celilo Falls was part of a nine-mile-long fishery that attracted thousands of people who took advantage of seasonal fish runs. Meriwether Lewis and William Clark called Celilo the "Great Mart of all this Country." The falls, which dropped over 80 feet in a tumultuous rush of water, created a thunderous sound that people remembered long after it was inundated by the construction of The Dalles Dam in 1957.

Traditional trade networks stretched beyond the Pacific Northwest to the north, south, and east, using a series of exchanges across the continent. People shared technologies, including use of European manufactured items, methods to create art, and horse-breeding practices. Europeans also transmitted something that would dramatically change the region — foreign pathogens. Disease epidemics, including smallpox and measles, decimated Native populations between the 1770s and the 1850s.

THE WORLD FINDS OREGON

Maritime explorers and traders mapped Oregon long before any foreigner stepped ashore. The earliest map of the West Coast was drawn in 1507 by a German cartographer who never saw it. People believed — or hoped — that North America could be traversed by ship from the Atlantic to the Pacific along a continuous waterway, known as the Northwest Passage, thereby avoiding the long and dangerous trip around the southern tip of South America.

By the 1790s, American, British, Spanish, and Russian maritime fur traders were operating in the North Pacific as part of a global trade network, but they had yet to find a river entrance to the Northwest Passage. The heavily forested Oregon Coast was protected by rocky landforms, rough tides, strong currents, and fog, which often thwarted close inspection of coastal inlets. Foreign governments and companies claimed territory on more accessible land primarily to the north, disregarding the ownership of Indigenous residents. Natives incorporated this trade, which brought such objects as guns, iron, and textiles, into their local economies.

➤

Coastal view from Chapman Point, Cannon Beach, 1912. Over 100 million years ago, Oregon's coast angled to the northeast from today's Siskiyou Pass toward Idaho. What is now western Oregon was under water. When the Siletz terrane approached North America 60 million years ago, it was too large to slide under the subduction zone, and its rocks piled up to form the foundation of the northern Coast Range. Tectonic movement and volcanic activity have built up the range and uplifted sedimentary deposits to create awesome headlands, such as Cascade Head and Chapman Point. Molten lava flowed from the east, solidifying when it hit the ocean, where it cooled to form the haystack-like formations that dot the coastline. *OHS Research Library, Org. Lot 140, b2, f37, photograph by Fred H. Kiser*

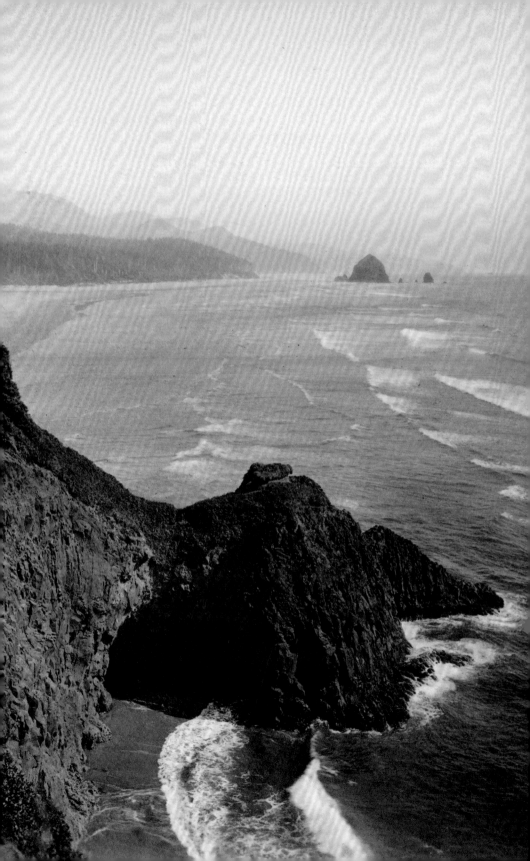

ASTONISHING VESSELS

Early maps forecasting a "great river" were proved true in 1792 when American merchant Captain Robert Gray spied the mouth of a river that "extended to the NE as far as the eye cou'd reach." He sailed a few miles upriver, observing beaches "lin'd with Natives, who ran along the shore following the Ship." Gray named the river the Columbia after his vessel, the 212-ton, 83-foot-long *Columbia Rediviva*.

John Boit, the ship's mate, recorded in his journal that the sight of the ship, carrying men jumping and swinging on its riggings, filled people on shore with "the greatest astonishment." Columbia River residents witnessed the beginning of new trade alliances; the transformation of the land and the constriction and loss of its resources; and the existential threats of disease, war, cultural assimilation, and dislocation, all in the form of an astonishing vessel.

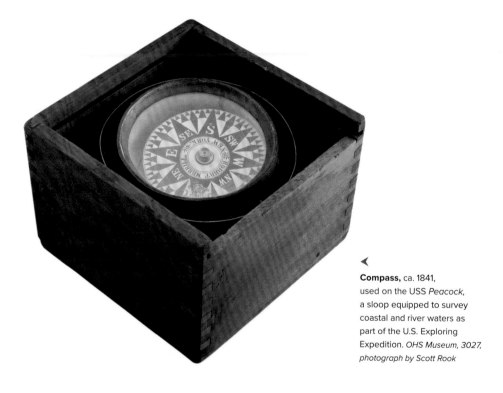

◄

Compass, ca. 1841, used on the USS *Peacock*, a sloop equipped to survey coastal and river waters as part of the U.S. Exploring Expedition. *OHS Museum, 3027, photograph by Scott Rook*

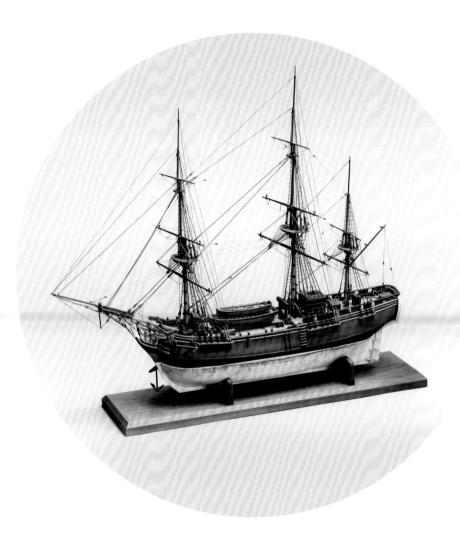

▲

Model of the *Columbia Rediviva*, 1966. Eighteenth-century sailing ships were engineering wonders, designed to carry sailors and cargo over long distances and under harrowing conditions. The *Columbia Rediviva* was a merchant vessel already famous for being the first American ship to circumnavigate the globe (1789–1790). In 1792, it was the first non-Native vessel to cross the Columbia River Bar. *OHS Museum, 71-89.1*

"SCENES OF ROMANTICK GRANDEUR"

The 1803 Louisiana Purchase did not include the Oregon Country, but it did open the West to American overland exploration. President Thomas Jefferson sent a military exploratory expedition to find a transcontinental water transportation route, to map the land and catalog flora and fauna, to note resources, and to survey Native peoples. The Corps of Volunteers for North West Discovery, led by Captains Meriwether Lewis and William Clark, set out from St. Louis in May 1804 with thirty enlisted men and York, Clark's personal slave. Interpreter Toussaint Charbonneau, his wife Sacagawea (Lemihi), and their newborn son Jean Baptiste joined them at Fort Mandan. Their route took them through present-day Missouri, Kansas, Iowa, South Dakota, North Dakota, Montana, Idaho, Oregon, and Washington.

The Corps descended the Snake and Columbia rivers in October and November 1805, overwhelmed by both the grandeur of the landscape and the rivers' navigational terrors. They reached the Pacific on November 18 and wintered on the south side of the Columbia (near today's Astoria) in a small structure they named Fort Clatsop after the local people. During that miserably wet, cold winter, members of the expedition explored the northern coast and the mouth of the Columbia, interacting with the Clatsop, Chinook, Nehalem, Neahkahnie, and Tillamook. They departed in March 1806 and arrived in St. Louis in September.

◀

Sewing kit (housewife), 1804–1806, carried by George Shannon, a member of the Corps of Discovery. Members of the Corps carried few personal items, but a housewife was essential. Only eighteen, Shannon was the youngest and greenest of the enlisted men and had the distinction of getting lost more than once, shooting wide of his hunting targets, and cutting his own foot while repairing a canoe. By the end of the expedition, Shannon was a capable woodsman and valued Corps member. *OHS Museum, 4014*

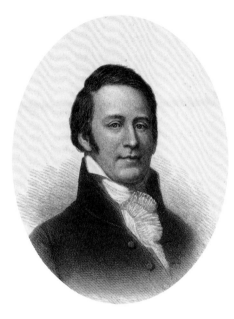

◄

Captain William Clark, ca. 1810, by Charles
Wilson Peale. Virginian William Clark
was a soldier, slave-owning farmer, U.S.
Superintendent of Indian Affairs for Louisiana
Territory, and territorial governor of Missouri.
He was a capable cartographer, and his
master map — *A Map of part of the Continent
of North America* (1810) — became a guide for
those who subsequently explored the West.
OHS Research Library, OrHi 97395

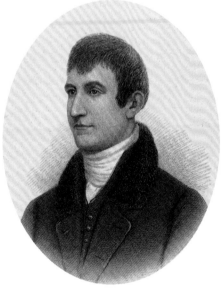

➤

Captain Meriwether Lewis, 1807, by Charles
Wilson Peale. Fellow Virginian Meriwether
Lewis was a soldier and personal secretary to
President Thomas Jefferson. His expedition
journals provide much of what we know about
the people and land in 1805–1806 western
America. Jefferson appointed him governor of
Louisiana Territory in 1807, but Lewis could not
overcome a melancholy that plagued him and
led to his death by suicide in 1809.
OHS Research Library, OrHi 9739

CORPS OF DISCOVERY: ITS MEMBERS AND LEGACY

The legacy of the expedition is imprinted on the landscape, both in the hundreds of monuments dedicated to the Corps and in the profound effect the journey had on the nation's interest in westward expansion. Lewis and Clark had confirmed that the Northwest Passage was a myth, but they had also completed an astonishing scientific exploration of vast landscapes, created a portfolio of maps, and surveyed dozens of Native communities. They had also noted the abundance of beaver and other fur-bearing animals, which prompted an expansive fur trade in the region.

Lewis and Clark's diplomatic efforts with Native groups were sometimes marred by the explorers' sense of superiority, but the expedition's engagements suggested that Natives were open to trade and political alliances. On the whole, the Corps members were effective ambassadors for the United States government, and their journey created a potential American claim to the Oregon Country.

Sacagawea was Agaideka (Lemhi) Shoshone, born and raised along the Salmon River in present-day Idaho. She was taken captive by members of the Hidatsa Tribe of the Upper Missouri before being traded as a wife to Toussaint Charbonneau. Their infant son, nicknamed "Pomp," accompanied the expedition. Clark believed that Sacagawea's presence signaled peaceful intentions, and Lewis and Clark often used her language skills and her knowledge of the land and its resources to their advantage.

York, an enslaved childhood servant and companion to Clark, accompanied the expedition as an uncompensated laborer, hunter, and assistant. He was an able mountaineer who elicited positive and curious reactions from Indians, most of whom had never seen a Black person. Although York requested his freedom after the expedition returned to Missouri, Clark kept him enslaved for another decade.

FUR TRADE AND BRITISH DOMINANCE

The first permanent non-Native settlement in Oregon was Fort Astoria, established by Americans at the mouth of the Columbia River in 1811. John Jacob Astor sent land and sea expeditions in 1810 to establish the Pacific Fur Company, which spent two years trapping and trading in the region before selling out to the Montreal-based North West Company in 1813.

No global power had claimed the Pacific Northwest when the Americans and their British counterparts planted their respective flags in Astoria. The terms of occupation — irrespective of the claims or interests of the tens of thousands of people already living in the region — were settled in 1818, when the United States and Britain agreed by treaty to a joint occupation of the Oregon Country. The boundaries of the region were refined in an 1824 treaty between the United States and Russia that set the northern border at 54°40' N. The British mercantile powerhouse, the Hudson's Bay Company (HBC), acquired the North West Company in 1821 and built Fort Vancouver in 1824 on the north side of the Columbia, upriver from the mouth of the Willamette.

▼ **Fort Vancouver,** 1845–1846. This hand-colored lithograph was based on a sketch drawn by Henry James Warre who was a British army lieutenant sent to the Pacific Northwest to ascertain the status of American settlement. Warre's original rough sketch shows Native people and figures who might have been French Canadian. *OHS Research Library, OrHi 83437*

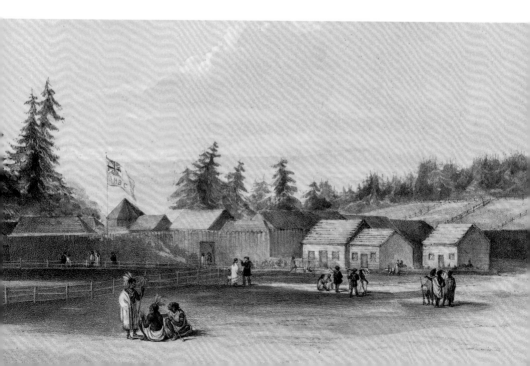

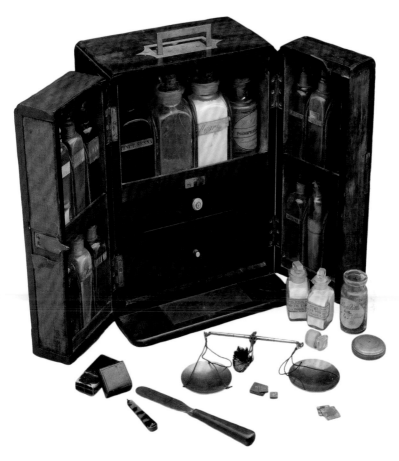

Medicine chest, 1818–1846, used by clerk James Birnie while working for the North West Company and Hudson's Bay Company. *OHS Museum, 1337.1.1-.27, photograph by Scott Rook*

Fort Vancouver was the headquarters of HBC's Columbia District, which operated a network of posts that stretched from Alaska to Mexico and from the Pacific to the Rocky Mountains. It supported a large, multicultural community of employees and their families, including Hawai'ians who lived in the nearby Kanaka Village alongside French Canadians, Métis, Cree, and Iroquois. By the time missionaries and farmers began arriving in the region, the company dominated the non-Native economy. Chief Factor John McLoughlin forged lasting relationships with Native leaders, including Chief Concomly on the lower Columbia, and also assisted American immigrants who settled in the Willamette Valley. He was devoted to his wife, Marguerite Waddens McKay (Ojibwe), whom he married in 1810. They formed a fortunate partnership, and she played a central role in the social, cultural, and political activities of the fort while raising seven children.

MISSIONARIES MOVE IN

In 1834, John McLoughlin persuaded missionary Jason Lee to operate in the mid-Willamette Valley, away from British interests in the upper Oregon Country. Former HBC employees were already farming in nearby French Prairie, but Lee's mission — just north of present-day Salem — marks the beginning of agrarian-based American settlement in the valley. In 1838, after struggling to convert Natives to Methodism, Lee returned to the East, where he convinced the Board of the Society of Missions to finance a Great Reinforcement of missionaries to Oregon. In 1840, fifty-one men, women, and children sailed to Oregon on the *Lausanne* to bolster the mission.

Catholic missionaries François Blanchet and Modeste Demers arrived in the Oregon Country in 1838 to serve local Catholics and convert Natives. They established an administrative center in St. Paul, eventually expanding their work into the growing towns of Oregon City and Portland. The first nuns in Oregon, the Sisters of Notre Dame de Namur, sailed up the Willamette River in 1844 to build schools and provide healthcare — a legacy that extends to the present with St. Mary's Academy and Providence Hospitals.

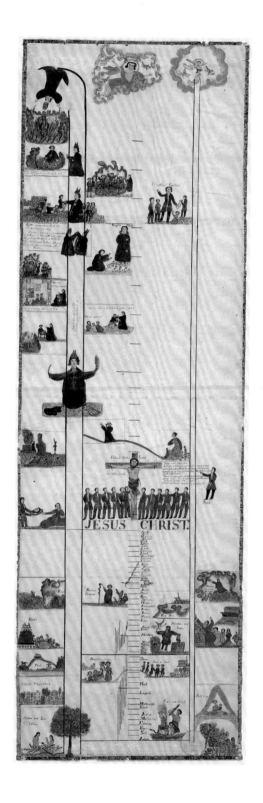

Protestant Ladder,
1845, created by
missionaries Henry
and Eliza Spalding at
Lapwai in present-day
Idaho. It was modeled
after a Catholic Ladder
created by François
Norbert Blanchet who
was ministering to the
Cowlitz. *OHS Research
Library, Mss 1202*

Catholic Ladder detail,
1840, created by French
Canadian Catholic
priest François Norbert
Blanchet. It is the
oldest known ladder in
existence. *OHS Research
Library, Coll 51*

Missionaries used
illustrated scrolls such
as these to explain
Christianity to Natives
by portraying theology
and human history
in pictorial images.
Missionary conversion
efforts of the mid-
nineteenth century,
supported by the U.S.
government, instituted
devastating policies
of forced cultural
assimilation, including
family separations,
creating generations-
long trauma.

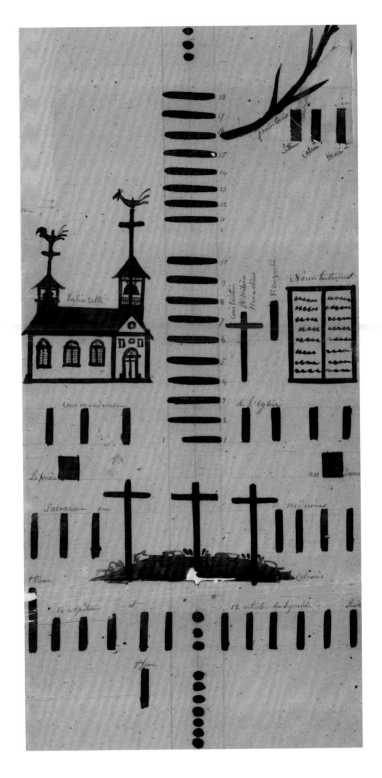

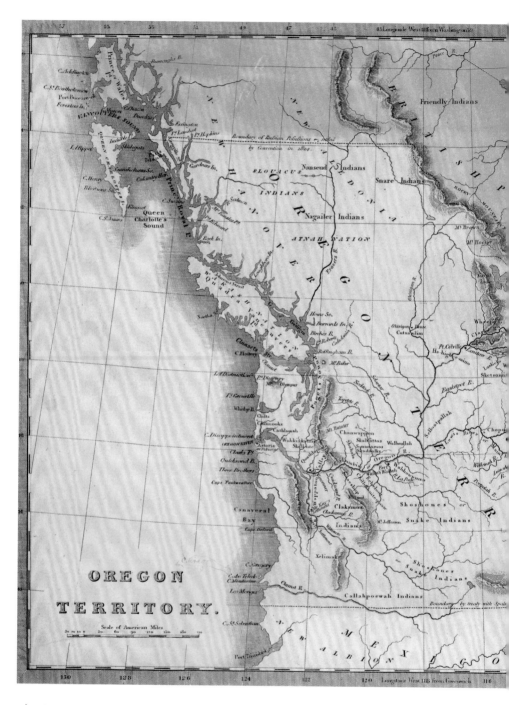

1833 Oregon Territory map, showing western and southern boundaries of British possession (pink) and the boundaries of the Oregon Country. *OHS Research Library, G4240_1842-G73*

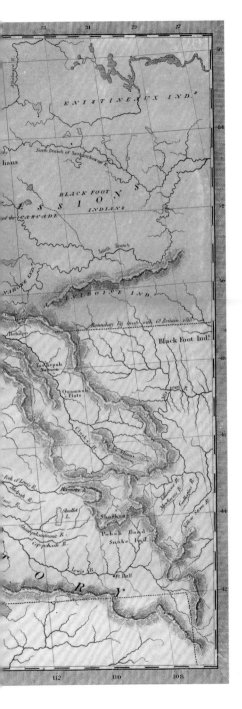

THE OREGON QUESTION

Early proponents of migration to the West relied on an ambitious concept to pull people from the Mississippi Valley across the continent on what was an uncertain and dangerous months-long journey to Oregon. In the 1840s they created a narrative — Manifest Destiny — to explain and justify western expansion, casting emigrants heading to Oregon as heroic figures serving the national interest. For the U.S. government, western migration had a political purpose. When the first sizable group of overlanders traversed the Oregon Trail in 1843, the United States still shared joint occupancy of the Oregon Country with Great Britain. Many Americans who settled in the Willamette Valley believed their presence argued for United States' sovereignty in the region. The Oregon Provisional Government, authorized by a popular vote in 1843, created an incentive for migration by granting emigrants up to 640 acres of land for farming. The trickle of wagon trains on the Oregon Trail became a torrent.

U.S.–British negotiations over how to resolve the joint occupation agreement — the so-called Oregon Question — resulted in a new treaty in 1846. The treaty split the Oregon Country, allotting lands south of the 49th parallel to the United States. Oregon became a territory in 1848, and Congress enacted perhaps the most consequential piece of legislation in the history of early American occupation, the Oregon Donation Land Act of 1850.

THE OREGON DONATION LAND ACT AND THE OREGON TRAIL

The Donation Land Act gave up to 320 acres of public land to married couples who emigrated to the Oregon Country (existing claims prior to 1850 were honored up to 640 acres). Women could hold title to their own 160 acres. The act was preceded by laws that bureaucratized the displacement of Natives in Oregon, first by necessitating treaties for the land and second by making Indians ineligible for land grants. By 1851, federal agents were negotiating with Native leaders to cede tribal homelands in exchange for protected reservations, recognition of sovereign government status, healthcare and education, hunting and fishing rights, and supplies.

▼ **Concertina,** 1852, brought to Oregon from Ohio by Rev. John Spencer.
OHS Museum, 3094, photograph by Scott Rook

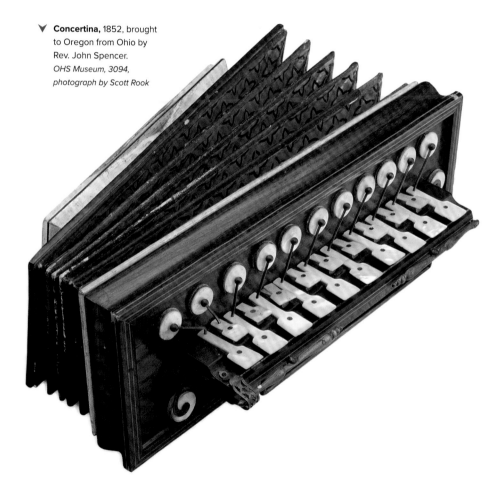

Cup and saucer, 1853, brought to Oregon by Mrs. T.J. (Beulah) Riggs. *OHS Museum, 1560, photograph by Scott Rook*

Ceramic dog figurine, 1852, brought to Oregon by Nathaniel Ostrander for his children. *OHS Museum, 3118.2, photograph by Scott Rook*

Crossing the 2,100-mile-long Oregon Trail took up to six months. Wagon trains "jumped off" in Missouri, upriver from St. Louis, and arrived in Oregon City on the lower Willamette River. Of the 300,000 to 400,000 people to make the crossing, about 10 percent died on the way. If there was space, emigrants wedged in personal items with plows and bags of flour. If the oxen faltered or an axle broke, those precious, impractical items were the first to be left behind. The anticipation, anxiety, rewards, and hardships of the trail were encapsulated in the phrase "Seeing the Elephant," a common saying that diarists used to describe the moment that was the most frightening and the most exhilarating. When emigrants made it through the final, difficult hurdles — the trip down the rapids of the Columbia River or the trek around Mount Hood — they entered the lush, green valleys of western Oregon.

SURVEYS AND SHIPPING

After the passage of the Donation Land Act, the U.S. government sent surveyors in 1851 to complete the Oregon Land Survey, a project that took four years. Cadastral surveys demarcated Townships and Sections, a federal requirement for legitimizing land claims. The territory was eventually mapped into a massive grid of prospective areas for settlement, leaving room for Indian reservations and natural barriers, such as mountains.

Farmers and miners needed supplies, and merchants shipped goods from the East Coast or San Francisco, selling them at significant markups in the small towns that began to populate the Oregon landscape. Enterprising men such as William S. Ladd in Portland made quick fortunes as retailers, allowing them to expand into even more enriching business ventures — banking, real estate, and transportation.

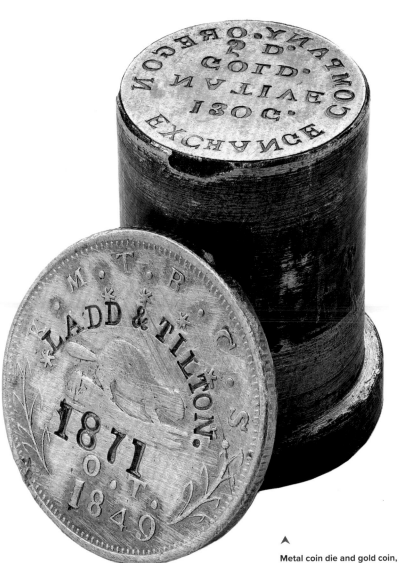

Metal coin die and gold coin, ca. 1849. The Oregon Exchange Company used this die to strike Beaver gold coins as currency in the Oregon Territory. The coins were made obsolete when the federal mint in San Francisco opened in 1854 and connected Oregon to a common U.S. monetary system. Only a few Beaver coins escaped the required collection and melting down of private coinage. *OHS Museum, 72-100.1.2, 72-186.1*

WAR AND TREATIES

From what you have said I think you intend to win our country.
— Piyópiyo Maqsmáqs (Walla Walla), 1855

The hospitality that Indigenous people had extended to fur traders and missionaries waned in the mid-nineteenth century as it became clear that Euro-American settlers expected tribes to give up their sovereignty and most of their homelands. The threats of land loss, communicable disease, and violence created tensions in interactions between Indians and the new settlers. Tribes knew they could not stop white emigration, and they knew that treaty negotiations were the only way to resist losing their lands and sovereignty. To these ends, tribal representatives agreed to accept limited reservations to retain tribal governance in exchange for annual provisions and infrastructure, a promise that the government would keep squatters off reserved land, and the perpetual right to hunt, fish, and gather foods in "usual and accustomed places." Indians were forced to relocate from their homelands to the reservations, and many suffered and died on Oregon's Trails of Tears.

When the U.S. government failed to uphold treaty guarantees — including clothing, food, and access to traditional hunting and gathering grounds — some tribes and bands resisted. Wars with volunteer militias and U.S. Army troops erupted in eastern and southern Oregon, and for thirty years Oregon was a battlefield — in the Columbia Basin, the Rogue Valley, the High Desert, and the southern lava beds. Not until the Nez Perce surrendered to regular army troops in 1877, and the Bannock conceded the next year, did the Indian Wars end in Oregon.

➤

Schonchin John and Kintpuash, 1873. The Oregon Indian Wars were front-page national news, especially the conflicts with the Modoc (1872–1873) and the Nez Perce (1877). Readers were riveted by the story of Kintpuash, "Captain Jack," who led a group of Modoc to a stronghold in the southern lava beds, holding off a U.S. Army unit six times larger. Heinmot Tooyalakekt, known as Chief Joseph, made headlines when he and his band of Nez Perce outpaced U.S. Army regiments on a 1,000-mile trek from central Idaho to near the Canadian border in present-day Montana. Kintpuash stands on the right in chains with Schonchin John; the U.S. government executed both men. Chief Joseph was exiled to Indian Country (present-day Oklahoma). He was never allowed to return to his Nez Perce homeland. *OHS Research Library, 0333P024, photograph by Louis Herman Heller*

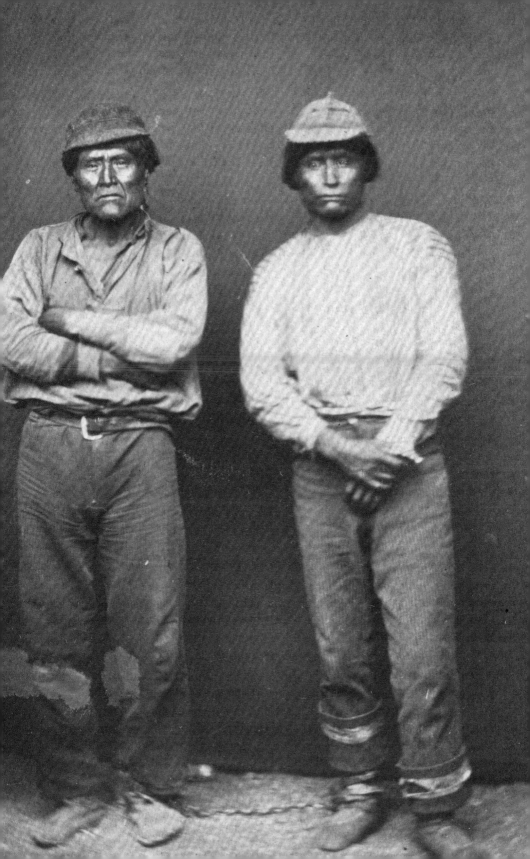

STATEHOOD

Determined to make Oregon a state, elected delegates to the Constitutional Convention, all white men, met in Salem in 1857. The state constitution they wrote privileged white men by excluding nonwhites and women from basic citizenship rights, including suffrage and equal access to the legal system. When the draft constitution went to voters for approval, the delegates offered two clauses for their consideration: should Oregon be a free state or a slave state, and should Oregon exclude free Blacks from legal residency. Voters overwhelmingly chose a free state and Black exclusion. The U.S. Congress reacted negatively to the delegates' attempt to avoid the slavery issue and debated Oregon's constitution for over a year before ratifying it. Oregon became the thirty-third state on February 14, 1859.

The exclusion laws had a profound impact on western migration. For years, many Black emigrants veered south to California or north to what would become Washington State. Enslaved emigrants traveled to Oregon with their owners, despite the territory's determination to be slave free. Once in Oregon, many Blacks either bought or sued for their freedom and became farmers in the growing territory. Oregon is the only U.S. territory to write Black exclusion laws into its founding document, a decision that opened the state to organized white supremacy into the twenty-first century.

▼ **Salem, Oregon,** 1855, the year the territorial capitol building went up in flames, possibly by arson. Oregon City and Corvallis had served as seats of government at various times until 1855, when the Territorial Legislature moved permanently to Salem. The matter was not officially settled until 1864, when voters chose Salem from a long list of towns and cities still vying for the honor. A second capitol building burned down in 1935, to be replaced by the present Modernist-style building. *OHS Research Library, 0170G056, photograph by Cronise Studio*

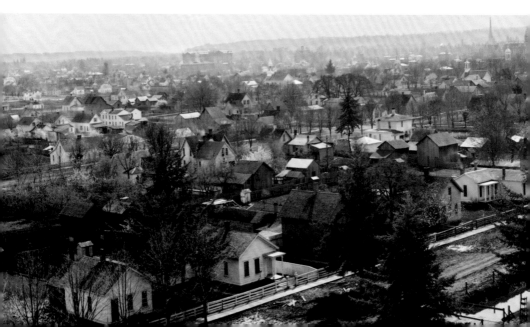

Multnomah County

(list of names, largely illegible)

Sauvie's Island Precinct

For the Constitution { yes 32 / no 11 } For Slavery { yes 13 / no 31 } For free negroes { yes 2 / no 39 }

Multnomah County

	For Constitution		For Slavery		For Free Negroes		Votes polled
	yes	no	yes	no	yes	no	
North Portland Precinct	142	78	34	179	24	174	220
South Portland Precinct	227	143	38	331	58	289	370
(Portland)	369	221	72	510	82	454	590
Powel Valley Precinct	25	5	0	30	6	21	30
Multnomah Precinct	17	1	0	18	3	15	18
Sandy Precinct	15	15	2	32	0	0	34
Willamette Precinct	23	1	11	13	8	16	24
St. Johns Precinct	19	4	2	18	0	20	20
Sauvies Island Precinct	32	11	13	31	2	39	45
	131	34	28	142	19	111	171
	500	255	100	652	101	565	761

Washington Co.

	Con — no	Sl — no	Negs — no
Hillsborough	97 – 63	22 – 139	14 – 144
Bute	19 – 29	1 – 47	13 – 34
Cedar Creek	34 – 18	7 – 46	8 – 43
Beaver Dam	18 – 12	1 – 29	9 – 19
Dairy Creek	7 – 21	7 – 21	5 – 19
Forest Grove	73 – 66	25 – 116	27 – 105
South Tualatin	17 – 17	5 – 30	4 – 29
	265 – 226	68 – 428	80 – 393

Clackamas County

	Con — no	Sl — no	Negs — no
Oregon City	193 – 87	41 – 242	53 – 212
Upper Molalla	41 – 33	19 – 56	4 – 63
Young's	21 – 3	5 – 19	3 – 20
Lower Molalla	29 – 22	11 – 41	6 – 43
Curry	19 – 2	2 – 19	0 – 21
Rock Creek	37 – 5	1 – 41	7 – 35
Tualatin	19 – 2	2 – 19	0 – 20
Mattoon's	27 – 12	8 – 30	6 – 29
Beaver Creek	35 – 1	2 – 33	1 – 34
Linn City	21 – 27	2 – 49	9 – 34
Milwaukie	45 – 12	1 – 56	23 – 34
Marquam's	43 – 10	4 – 50	1 – 44
Total 530	530 – 216	98 – 655	113 – 594

▲ **Preliminary voting abstract,** 1857. On November 9, 1857, eligible Oregonians (white men) voted to ratify the proposed Oregon State Constitution. This abstract is a record of votes for and against slavery, the exclusion of free Blacks, and for the constitution itself. It corresponds closely with the final election results in Multnomah, Washington, and Clackamas counties, which voted overwhelmingly to oppose slavery and restrict free Blacks from residing in the state. *OHS Research Library, Mss 1227, b1, f1a*

OREGON FARMLAND, A "GOLDEN HORN OF PLENTY"

Nineteenth-century Oregon was primarily an agrarian economy, and the state's 16 million productive acres that remain are the result of aggressive land management legislation. Former fur trappers who built farms near French Prairie in the mid-Willamette Valley were surrounded by overlanders who grabbed land throughout the valley, then south into the Rogue Valley, west to the coast, and finally east of the Cascades, where they dry farmed and ranched. Oregon Trail settlers planted mostly wheat — over 2.3 million acres of it by 1870. Today's farmers sustain healthy markets of hops, nuts, apples, pears, cranberries, cherries, grass, ornamental plants, and Christmas trees — and that is the short list. Almost half of the state's dairies operate in coastal Tillamook County, supported by cooperatives formed over a century ago. Japanese immigrants in east Multnomah County and the Hood River Valley bought lands for farms and orchards, many of which have remained in families for generations.

▲ **Hops pickers at Livesley Hop Yard,** ca. 1925. The first commercial hop yard in Oregon was planted in 1867, and most of the early production of this perennial, cone-producing plant occurred on family farms. *OHS Research Library, OrHi 3648*

◀ **Pulled flax in shocks for drying and curing,** ca. 1930s. Oregon's soil and climate are ideal for growing flax, and Native people used wild flax for bags and baskets. White settlers imported flax seeds, establishing a thriving industry that once dominated the global flax market. *OHS Research Library, Org. Lot 859, box 20, no. 5, photograph by Arthur Prentiss*

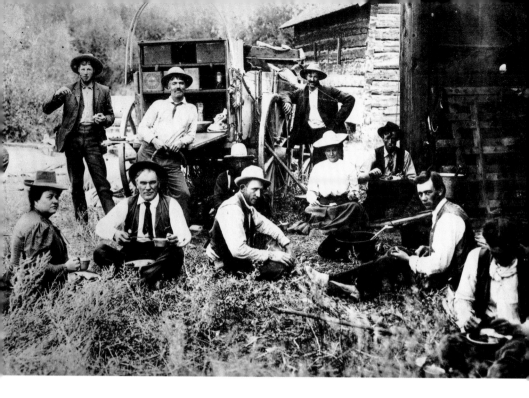

▲ **Peter French's ranch crew,** ca. 1890. Today, much of French's former land is managed by state and federal agencies, which regulate grazing access and manage wildlife refuges. They also cooperate with tribal governments to maintain the economic, political, and cultural sovereignty of Native people throughout the region, including the Confederated Tribes of the Umatilla Indian Reservation and the Burns Paiute Tribe. *OHS Research Library, OrHi 4277*

CATTLE AND SHEEP RANCHING

Most of the land west of the Cascades was settled by individual farmers in a patchwork of federal land claims. Many claims east of the Cascades, however, were gradually monopolized by large ranching companies. As farmers lost their battle against High Desert soil, due to a lack of irrigation and harsh weather, stock companies gobbled up their claims and consolidated control over the landscape. Perhaps the most notorious of the empire-building stockmen was Pete French, whose French-Glenn Live Stock Company ran 30,000 head of cattle over 200,000 acres in the Blitzen Valley. The unpopularity of his sometimes ruthless land-acquisition methods led to his murder in 1897. His killer was exonerated.

MINING

A gold rush during the 1850s enticed thousands of miners to the Illinois River in Jackson County in southwestern Oregon. For the next four decades, mining claims — and the small towns that serviced the miners — populated southwestern and eastern Oregon. Gold was the most coveted mineral, but miners also pulled silver, cinnabar, chromite, and borax from the earth. Mining is no longer a primary industry in the state, but towns such as Jacksonville and Baker owe their start to the hasty need for supply centers. The landscape still carries scars created by equipment and forced erosion.

The mining boom was a flashpoint for racism and violence. Miners often ignored federal law in assuming control of Indian lands, and local Indian agents were reluctant and ill-equipped to stop them. Chinese miners faced virulent racism, including the brutal massacre of thirty-four men in 1887 by white men and boys at Deep Creek along the Snake River. None of the murderers were jailed.

▼ **Chinese suitcase with hat storage,** late nineteenth century. This box, belonging to businessman Moy Back Hin, was designed to accommodate a conical hat, brought to the region from China. Conical hats were well-suited to both sun and persistent rain. Most were made of plant fibers, such as straw or bamboo, and were secured with a comfortable chinstrap, usually made of silk. *OHS Museum, 88-30.13, photograph by Scott Rook*

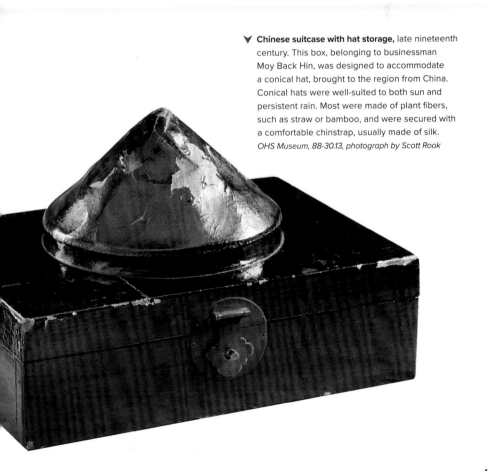

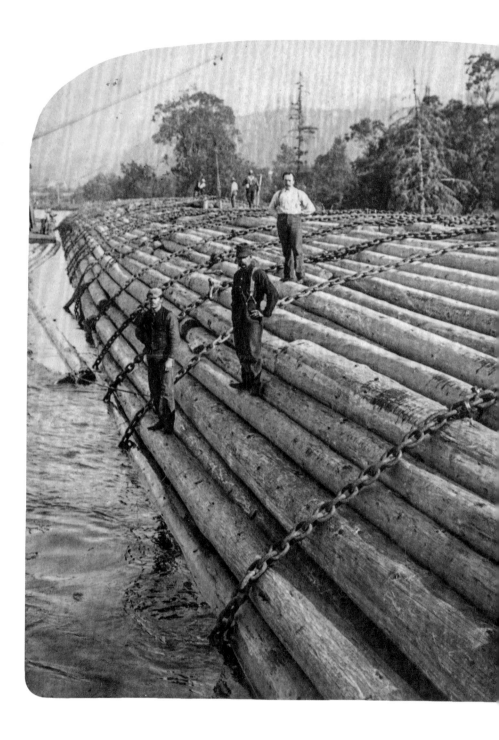

TIMBER

Oregon's trees, whose size once intimidated and slowed white settlement, fueled an economic powerhouse that is etched into the identity of the state. Fur traders and early white settlers cleared land, built sawmills, and sold lumber to distant markets. Oregonians used the timber for houses, buildings, boats, and fencing. But timber harvesting was not a serious commercial enterprise until the 1880s, when transportation systems became sophisticated enough to move the felled timber to mills. Despite economic dips in the 1920s and 1930s, Oregon trees sustained dozens of communities, including the company-built towns of Maxville, Hines, and Brookings, and made Oregon the leading producer of wood products in the United States.

But harvesting slowed and then fell substantially in the 1990s, when regulations reduced timber extraction to address the environmental effects of logging on old-growth forests and the habitats of endangered species. The listing of the spotted owl as an endangered species became a symbol of both environmental protections and the economic injury to timber towns. The tension intensified into the Timber Wars, which continue to reverberate as political, cultural, and geographic divisions among Oregonians.

Log raft, Troutdale, 1902. After cut timber had been dragged from the forest to a nearby river, by oxen or railway, it was often chained together into giant rafts as large as three football fields. Nimble loggers rode the rafts and guided them downriver to the mills. Invented by Oregon timber baron Simon Benson, the "cigar rafts" — so named for their likeness to bundles of cigars — were so efficient that timber companies used them to transport logs on the ocean. *OHS Research Library, CN 018169, photograph by Underwood & Underwood*

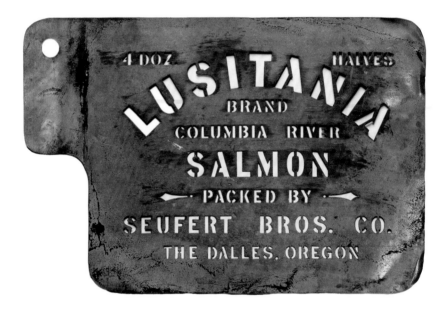

▲ **Metal embossing stencils,** 1886–1894. These stencils depict the logo of the
Seufert Brothers Company, which canned fish, fresh fruits, and vegetables in the
late nineteenth century. From 1866 into the early 1920s, canneries on the Columbia
and Rogue rivers generated thousands of pounds of canned salmon every year.
They contracted with Native fishers and hired Chinese and Scandinavian laborers,
many of them women, to gut and can the fish. Fish wheels, rotating machines that
scooped fish out of a river, collected up to a half-ton of fish each day from the
Columbia. They were so effective that Oregon banned them in 1928 to protect the
fish populations. *OHS Museum, 80-50.1.17, .18*

FISHING

Salmon, the state fish, have fed people in the region for thousands of years. The aptly named June Hog (summer Chinook) can reach more than 85 pounds. Oregon's interconnected waterways from the ocean, particularly in the Columbia and Willamette river basins, are ideal for sustaining huge populations of anadromous fish, including sturgeon and six species of salmon. The species' biology and the environment that sustains them make salmon both vulnerable to ecological disruption and easy to catch.

Fish populations began to decline in the second half of the nineteenth century when commercial fisheries promoted over-harvesting. Even then, millions of fish returned to Oregon each year, many of them netted and scooped out of the water by canneries. By the second half of the twentieth century, most of the fish caught had been bred in hatcheries.

The ups and downs of the fishing economy have had profound effects on Native fishers, who are entitled by treaties to fish at "usual and accustomed places." Nevertheless, they have been blocked from fishing sites and banned by state laws that regulate harvesting quotas. When fish habitats lose out to irrigation for farming and hydroelectric power, tribes lose the fisheries they have been connected to for thousands of years. In the twenty-first century, tribal agencies are at the vanguard of fish restoration in Oregon and have become partners with farmers and power agencies in managing fisheries.

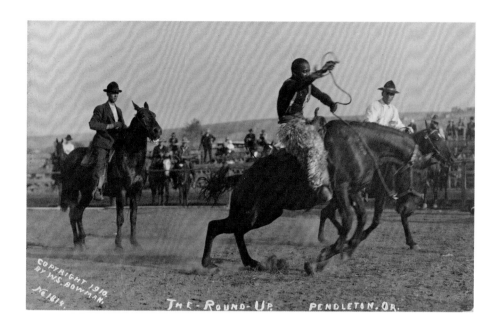

PENDLETON

Pendleton is on the homeland of the Confederated Tribes of the Umatilla Indian Reservation (CTUIR), which still own the land east of the city. Pendleton developed around a trading post, established in 1851 by William McKay (Chinook, Scottish-Ojibwa), that grew into a farming and ranching community. Incorporated in 1880, Pendleton was an important transportation hub for the wool market, surrounded as it was by sheep ranches. Pendleton Woolen Mills, established in 1909, began manufacturing blankets for Native buyers, imitating Native designs to produce beautiful patterns that found a global market, making the brand world famous.

The town is also famous for the Pendleton Round-Up held every fall. The event is a collaboration between the town and the CTUIR, a partnership that dates to the rodeo's founding in 1910. One of the most famous Native riders at the Round-Up was Waaya-Tonah-Toesits-Kahn (Nez Perce), who competed under the name Jackson Sundown. He became the World Champion Bronco Rider in 1916 at the age of fifty-three. Sundown was so good, riders often defaulted rather than compete against him.

COWBOYS AND COWGIRLS IN OREGON

Vaqueros, Mexican cattlemen and women from what is now northern California, brought cowboy culture to Oregon. In 1869, rancher John Devine hired *vaqueros* to drive a herd of cattle to establish the Whitehorse Ranch east of Steens Mountain. More *vaqueros* followed, and white cattlemen adopted their skills and customs. The word *vaquero* was later anglicized to "buckaroo," but the traditions endured and were adapted to the local horse culture that also includes Native skills and techniques.

◀ **George Fletcher at the Pendleton Round-Up,** 1910. Fletcher, one of the Round-Up's most famous cowboys, learned much of his horsemanship from Native riders on the Umatilla Indian Reservation. For years, he traveled the West entertaining audiences with his distinctive style. *OHS Research Library, photo file 85-n, photograph by Walter Scott Bowman*

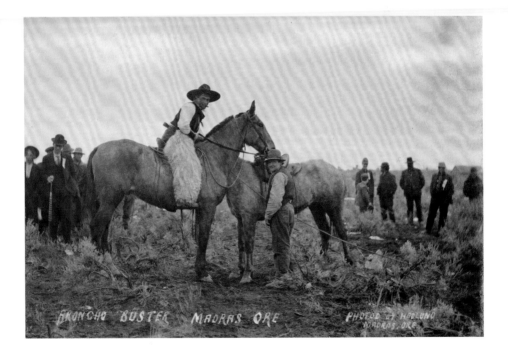

▲ **Bronco buster, Madras, Oregon,** ca. 1910. Cowboys prepare to break a young horse near Madras, a ranching and farming community in central Oregon, just east of the Warm Springs Reservation. *OHS Research Library, 0329P023, photograph by Ole Hedlund*

TRANSPORTATION: "GET OREGON OUT OF THE MUD!"

Farmers depended on an interconnected transportation network to move wheat and other commodities to market. They built roads and railways to rivers, used steamships to reach mills, and relied on ports to ship goods to the rest of the world. Farm-to-market roads were a priority for new settlers, and efforts to build passable routes began as early as the 1840s.

The earliest plank road out of Portland, built in 1852, was a rickety affair, no match for Oregon's rain and mud. As technology improved, however, market roads connected most towns and mills to urban centers, a network that is still in use today.

Railroads opened interior Oregon to industry and settlement, and small towns depended on them. Federal land grants to railroads promoted development, but the grants also generated sophisticated fraud schemes and led to corporate bankruptcies and abandoned lines. Nonetheless, the legacy of Oregon's railroads is inextricably bound to the land they opened for development, the fortunes made and lost, and a built environment that hugs thousands of miles of track.

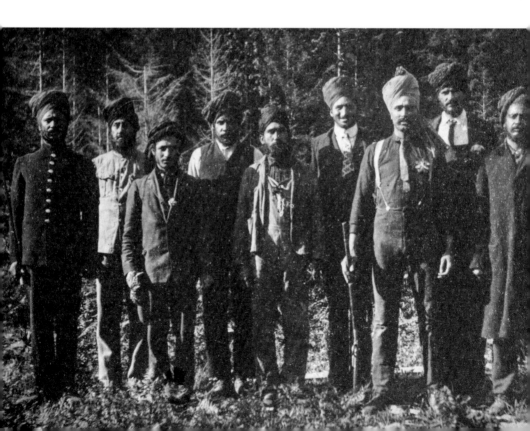

Railroad spike, 1883. The first transcontinental railroad to reach Oregon huffed into Portland on September 11, 1883. A trip that once took months now took a few days. This spike, used on the Northern Pacific Railroad, engraved with "Last Spike," was driven on September 8, 1883, at Gold Creek in western Montana. *OHS Museum, 2004-1.9, photograph by Scott Rook*

East Indian railroad workers, 1910. The most intense period of railroad-building in Oregon, during the late nineteenth and early twentieth centuries, coincides with the history of immigrant labor in the Northwest. Railroads recruited Chinese, East Indian, Japanese, and European workers to the American West, where they were often met with xenophobic legislation and harassment by white residents. The paradoxical tension between the reliance on and recruitment of immigrant labor, including Sikhs, and the systematic discrimination against those workers characterize every period of industrial and economic growth in Oregon history. *OHS Research Library, Org. Lot 1171, album 509*

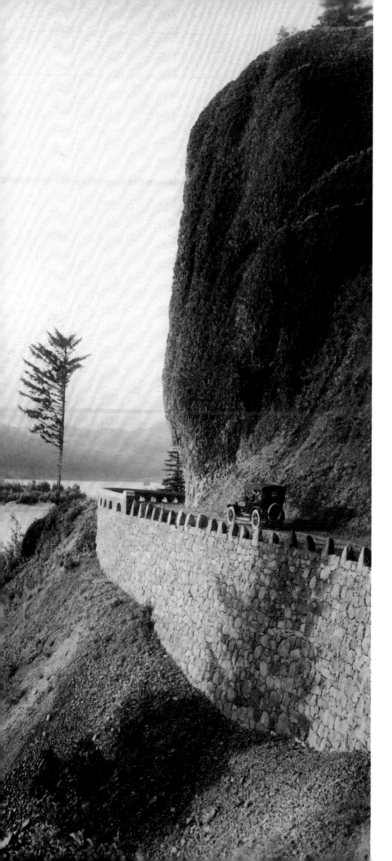

◀ **Bishop's Cap,** n.d., near Shepperds Dell along the Columbia River Highway. *OHS Research Library, Org. Lot 140, b5, f49*

▼ **Benson automobile,** 1904–1906, built in Oregon, featuring a four-cylinder engine and wooden spoke wheels. *OHS Museum, 99-41.1.1-4, photograph by Scott Rook*

OREGON ENTERS A NEW CENTURY

Automobiles arrived in Oregon in about 1899. Auto tourism followed, in part because conservationists discovered that people were more willing to preserve natural landscapes — such as Multnomah Falls and Crater Lake — if they could experience them in person. The project was not without controversy, as Oregonians argued against using tax dollars to build roads designed for leisure and with little practical use for the average person, who was likely carless.

One of Oregon's most glorious scenic roads is the Columbia River Highway. From 1913 to 1922, laborers blasted through rock, leveled ground, and built stone walls and tunnels designed to enhance, not disrupt, the natural beauty of the Columbia River Gorge. The road was an engineering wonder, complete with sophisticated drainage systems and reinforced-concrete bridges. When the first section opened in 1915, it was the first paved highway in the Northwest. The highway eventually extended east to Pendleton and west to the coast. Parts of the original highway, now a historic landmark, are still used, and entire sections have been dedicated for walking and biking trails. A four-lane interstate highway hums below.

▲ **Portland, Oregon,** ca. 1923. This view north on Fifth Avenue, between Yamhill and Morrison streets, was hand-colored on a lantern slide by Arthur M. Prentiss. Portland's Chinatown, now located at the north end of Fifth Avenue, is one of the oldest in the West, established by Chinese immigrants who were among the earliest non-Native settlers in the region. Chinese businesses and cultural institutions were integral to the development of the city, yet residents were subjected to exclusion laws, police raids, and anti-Chinese riots. *OHS Research Library, Org. Lot 301, 14204*

FROM STUMPTOWN TO THE ROSE CITY

By the turn of the twentieth century, Portland had won the race to become the most significant metropolitan area in the Northwest. Its merchant class was determined to make Portland a metropolitan city modeled after Venice and Paris. That ambition led to national searches for architects and city and park designers, such as A.E. Doyle, Robert Moses, and the Olmsted Brothers. What began as a small clearing down the river from well-settled Oregon City became a bustling marketplace and port with transportation and economic ties to San Francisco, Seattle, and China. Portland doubled in size when it annexed the cities of East Portland and Albina (1891) and St. Johns (1915).

▲ **Portland Penny,** 1835. The Portland Penny is an 1835 American copper coin used to name the newly platted town. The oft-told story has two of Portland's first landholders, Asa Lovejoy and Francis Pettygrove, at dinner in 1845, agreeing to flip a coin for naming rights. Pettygrove retrieved a penny from his pocket, and they agreed to a two-out-of-three-toss contest — Boston if Lovejoy won, Portland if Pettygrove won. With three tosses of a penny, Portland got its name. *OHS Museum, 68-534*

OREGON'S "GREATEST DAYS"

The culmination of Portland's ambitions is perhaps best exemplified in the 1905 Lewis and Clark Centennial and American Pacific Exposition and Oriental Fair, a 182-acre fairground created on the Willamette River north of the city. Designed to promote modern technology and the viability of Oregon resources in the global economy, the exposition was an extravagant display of architecture and spectacle. From June to October, the fair hosted a million and a half visitors who stayed in Portland hotels, visited the city's sites, and considered real estate and business opportunities in a port city made beautiful by a temperate climate and a coordinated rose-planting campaign. Among the fair's displays were human exhibits of Indigenous people from the Northwest and around the world, placed to emphasize a racial hierarchy in contrast to the "western progress" celebrated at the fair. Colonialism — and the suffering it caused — was reduced to a racist sideshow.

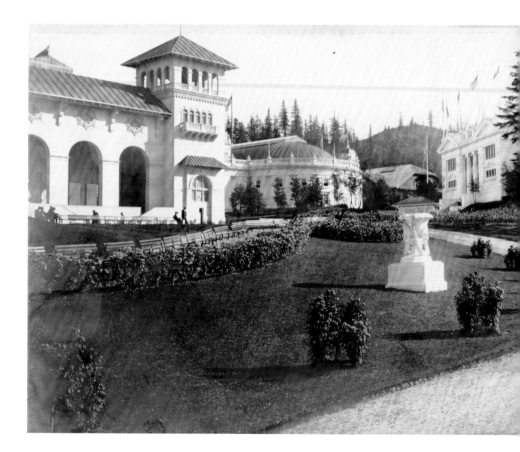

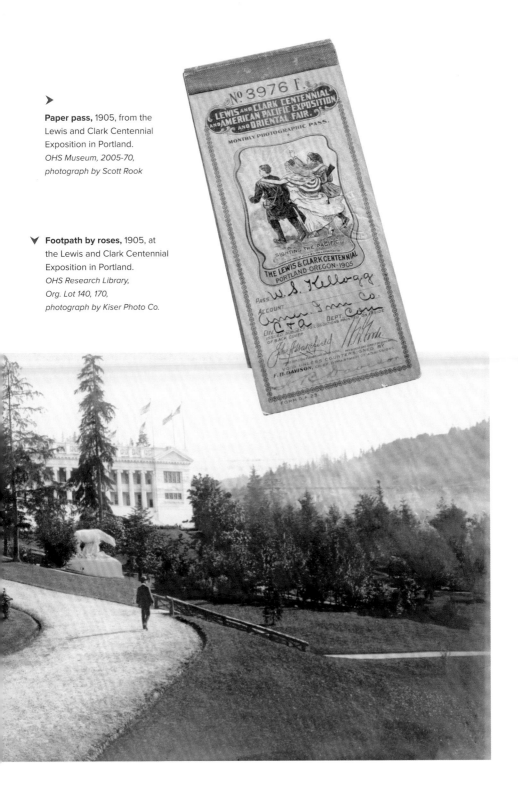

Paper pass, 1905, from the Lewis and Clark Centennial Exposition in Portland.
OHS Museum, 2005-70, photograph by Scott Rook

Footpath by roses, 1905, at the Lewis and Clark Centennial Exposition in Portland.
OHS Research Library, Org. Lot 140, 170, photograph by Kiser Photo Co.

PROGRESSIVE ERA AND THE OREGON SYSTEM

During the Progressive Era, social reformers targeted moral issues, especially alcohol intemperance and prostitution. Others focused on the cultural assimilation of immigrants; Jewish organizations, for example, supported newcomers with kindergartens and language classes. Labor activists took on low pay and poor working conditions, particularly for women, spearheading pro-labor demonstrations and the creation of regulatory agencies. Political reformers took to the streets to march and make speeches, sometimes clashing with police. Activists filled speaking halls and theaters and, often, city jails.

Perhaps the most significant reform in the history of the state, which made hundreds of other reforms possible, was the Oregon System. Led by lawyer William U'Ren, the Populist Party outmaneuvered legislative leaders between 1898 and 1908 to institute the initiative, the referendum, the direct election of senators, and the recall. The initiative and referendum process has led to groundbreaking laws in Oregon, including woman suffrage, death with dignity, and the legalization of marijuana. It has also cluttered the ballot with special interest laws, often poorly written and impossible to implement. Over a century later, Oregonians continue to embrace — and mock — their populist system.

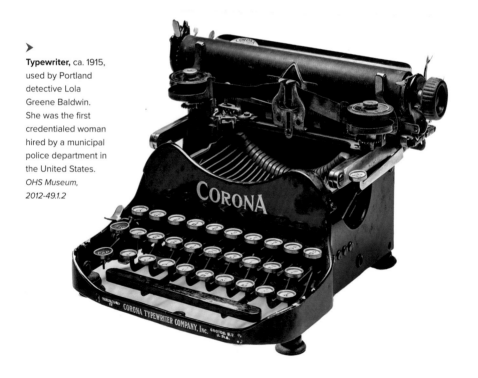

➤

Typewriter, ca. 1915, used by Portland detective Lola Greene Baldwin. She was the first credentialed woman hired by a municipal police department in the United States. *OHS Museum, 2012-49.1.2*

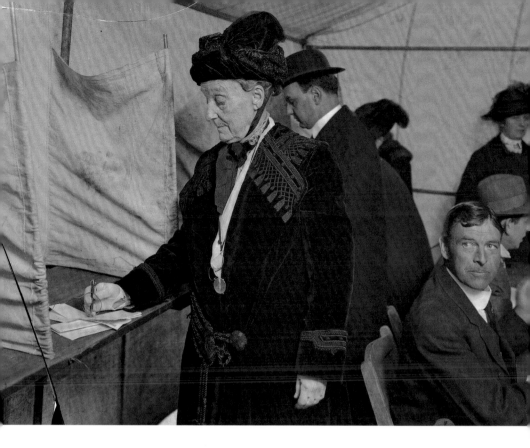

▲ **Abigail Scott Duniway votes,** 1912. When women finally gained the right to vote in Oregon in 1912, Duniway was one of the first women to register to vote in Multnomah County. *OHS Research Library, Org. Lot 139, neg. 4601*

SUFFRAGE

Woman suffrage was one of the longest organized political movements in Oregon. The Oregon constitution explicitly restricted voting to white men. The Fifteenth Amendment in 1870 nullified the race requirement but left the ban on women in place. It took over forty years of activism, coalition-building, speechmaking, editorials, conventions, parades, and door-knocking in Oregon to pass the woman suffrage bill in 1912.

An indefatigable activist, Abigail Scott Duniway is the most recognized leader of the Pacific Northwest movement to give women the vote. The editor and publisher of *The New Northwest*, she worked with national leaders, including Susan B. Anthony and Anna Howard Shaw. Governor Oswald West recognized Duniway's contribution to women's rights by choosing her to sign the Equal Suffrage Proclamation in 1912.

WAR, DEPRESSION, AND DAMS

Shipbuilding and lumber production were invigorated by federal work orders during World War I, and the devastation of European farms opened the global market to Oregon agriculture. Wood products were so in demand that in 1917 the government put enlisted men to work for the Portland-based Spruce Production Division, which supplied spruce for airplane production.

The war encouraged anti-immigrant sentiment, and expressions of patriotism carried authoritarian overtones. Citizens were pressured to buy bonds at the risk of losing their jobs, and state laws prohibited public speech and writing against the war. Labor unions were targeted and their leaders jailed for sedition. Oregon was divided by nationalism and anti-war, pro-labor sentiment.

World War I relieved some of the economic pain from recent panics and recessions, but it was not enough to buffer Oregon from the high unemployment and hyperinflation of the post-war years. When the stock market collapsed in 1929, unemployment rose, devastating businesses and savings. The state welcomed federal New Deal programs, such as the Works Progress Administration, that hired local workers to build infrastructure and to create literature, art, and public history projects. The legacy of the New Deal is visible throughout Oregon.

The construction of multipurpose dams on the Columbia River was approved by President Franklin Roosevelt to increase employment and aid industrialization. The Bonneville Dam was completed in 1938, followed by the construction of nearly 300 major dams in the Columbia River Basin, and hundreds more along other water systems, increasing irrigated agriculture and making hydropower one of the most important sources of energy in the region. By the 1970s, it was clear that the dams imperiled fish, which led to cooperative solutions by government agencies, tribes, and power companies. Replacing hydroelectric power with something just as renewable and affordable, however, is an ongoing problem that, for now, leaves most dams in place and fish on the edge.

➤

Soldiers riving a log, ca. 1918. During World War I, almost thirty thousand U.S. soldiers were assigned to the Spruce Production Division. All enlistees were required to join the Loyal Legion of Loggers and Lumbermen (4L), a government-created union formed in late 1917 to counteract widespread labor strikes by workers in the industry. *OHS Research Library, Org. Lot 1062, b1, 002*

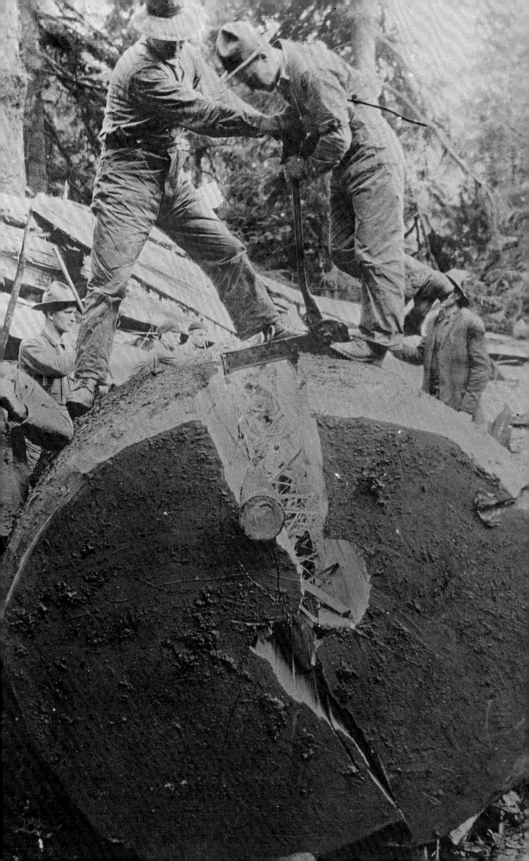

WAR AGAIN

Once the United States declared war on Japan in 1941, a different Oregon emerged from the Great Depression. Tens of thousands of people migrated to the state after Henry Kaiser's West Coast shipyards extended north to include two yards in Portland and one in Vancouver, Washington. Rural Oregonians migrated to the cities, leaving farmers scrambling for labor at a time when they were ramping up production. Farmers relied on the Women's Land Army and other government labor programs, notably the Mexican Labor Program and the Oregon Plan, which employed Japanese Americans imprisoned during the war.

The military draft sent thousands of Oregonians overseas, and the state relied on women, children, and immigrants to fill the gaps in the workforce. Women found well-paying, skilled jobs, flooding the male-dominated retail sector and speeding up the creation of a professional office labor force.

◄
Welder's mask, 1939–1945. Shipyards throughout the country held welding contests for both men and women, rewarding skill and emphasizing regional company loyalty. This welding helmet belonged to Hermina Strmiska, who worked at the Kaiser Shipyards and took second place at the national welder's competition in 1943. *OHS Museum, 2004-17.1, photograph by Scott Rook*

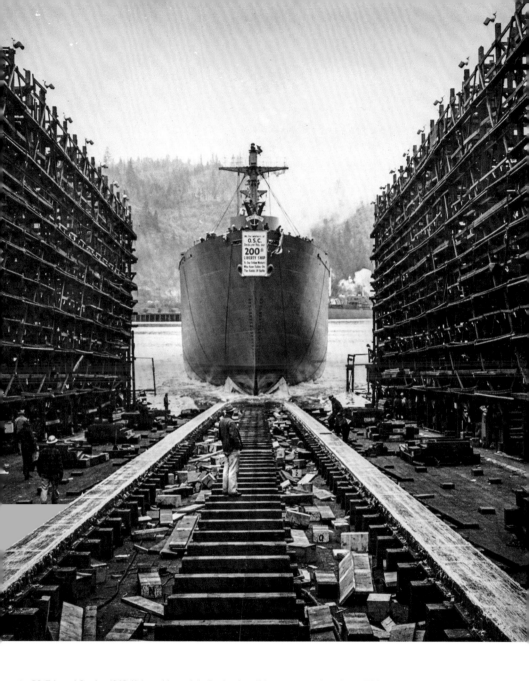

▲ **SS *Edward Canby*,** 1943. Kaiser shipyards in Portland and Vancouver produced over 700 wartime vessels during World War II. The SS *Edward Canby* was the Oregon Shipbuilding Corporation's 200th Liberty ship, shown here in its celebratory launch on June 12, 1943. Kaiser's Northwest shipyards, located along the Columbia and Willamette rivers, employed as many as 97,000 workers. A Liberty ship took an average of 42 days to build, but the Oregon Shipbuilding Company set a speed record in 1942 when it completed the Liberty *N. Teal* in ten days. The shipyards operated 24 hours a day and gave workers pre-made meals, 24-hour daycare, and medical services.
OHS Research Library, OrHi 68566

POLITICS OF FEAR

There was a liveliness about 1940s Oregon that celebrated patriotic cooperation and a strong economy, but one of the state's and the nation's most shameful moments occurred during this time. Oregon participated in the surveillance and restriction of civil rights on Japanese and Japanese Americans living in the state. On February 19, 1942, President Franklin Roosevelt signed Executive Order 9066, which ordered the incarceration of all people of Japanese ancestry on the West Coast. Children were pulled from school, and Japanese people were ordered to leave their jobs, homes, businesses, and farms to report to holding centers before being sent to interior prison camps. The camps were closed in 1945, but the legacy of economic and cultural damage to incarcerated Oregonians remains.

▼ **Broadside of Western Defense Command,** May 6, 1942. This broadside, directed at both Japanese immigrants and Japanese Americans, ordered residents in Clackamas and east Multnomah counties to surrender to detention before incarceration at one of several camps in the West.
OHS Research Library, Coll 619

WESTERN DEFENSE COMMAND AND FOURTH ARMY
WARTIME CIVIL CONTROL ADMINISTRATION
Presidio of San Francisco, California
May 6, 1942

INSTRUCTIONS
TO ALL PERSONS OF
JAPANESE
ANCESTRY
Living in the Following Area:

All of the County of Clackamas, State of Oregon, and all of that portion of the County of Multnomah, State of Oregon, east of the west side of 122nd Avenue and the extension thereof, from the northern limits of the said county to the southern limits of said county.

Pursuant to the provisions of Civilian Exclusion Order No. 46, this Headquarters, dated May 6, 1942, all persons of Japanese ancestry, both alien and non-alien, will be evacuated from the above area by 12 o'clock noon, P. W. T., Tuesday, May 12, 1942.

No Japanese person living in the above area will be permitted to change residence after 12 o'clock noon, P. W. T., Wednesday, May 6, 1942, without obtaining special permission from the representative of the Commanding General, Northwestern Sector, at the Civil Control Station located at:

Administration Building,
Gresham Fair Grounds,
Gresham, Oregon.

▲ **Police officers respond to Vanport flood,** May 1948. A group of police officers and residents walk across a broken bridge and search through debris left by the Vanport flood. *OHS Research Library, Org. Lot 131*

VANPORT

By 1944, Portland's Black population had grown from 2,000 (1940) to 22,000, the result of industrialist Henry Kaiser recruiting workers for his shipyards. Faced with race-based restrictive covenants that constricted housing for his employees in Portland, Kaiser made a deal with the government to build semi-integrated housing developments. The largest was Vanport, built along the Columbia River north of Portland, with housing for 42,000 residents, making it the second most-populated city in the state. Several years later, in May 1948, Vanport was destroyed when the Columbia River flooded, roaring through the streets. The town was undone and unsalvageable, and 18,500 people were homeless.

BLACK OREGONIANS AND CIVIL RIGHTS

The influx of Black residents from Vanport to Portland laid bare the persistence of racial inequality in the state. White Portland attempted to contain Black residency in designated neighborhoods by using redlining and housing covenants, and planning bureaus used eminent domain to wipe out Black neighborhoods and business districts to build, among other things, a sports arena and a freeway and to make room for a hospital extension. Black Oregonians pushed back.

The civil rights movement in Oregon was led by skilled organizers and their allies, who used community-building systems — such as churches and YMCAs — to create coalitions. The movement was a continuation of decades of activism by members of the Black community, who had protested Oregon's racial hierarchies since the nineteenth century. The creation of the Urban League in 1945 allowed local activists to use national resources for support. By 1953, the Black community had helped write and pass Oregon's Civil Rights Bill, which made it illegal to discriminate by race in public accommodations. Local leaders arranged protests, published housing and employment studies, and engaged school districts. The Black Panthers created a free breakfast program and health clinic, and Oregon voters elected Black judges and political leaders.

➤

Possum Rally, protest on March 25, 1981. The history of racism in Oregon is tied directly to the exclusion clauses in the state constitution, the popularity of the rejuvenated Ku Klux Klan in the 1920s, and the often violent over-policing of Black communities and residents. In 1981, for example, Portland police officers tossed dead possums at a Black-owned restaurant as a "prank." Charles Jordan, Portland's first Black city commissioner, joined protestors at City Hall. Moments of that protest are captured in this 16mm frame sequence. After he fired two of the officers involved, Jordan received death threats, and the Portland Police Association successfully lobbied to reinstate the officers. *OHS Research Library, KPTV News Film Collection, MI 07524, R2*

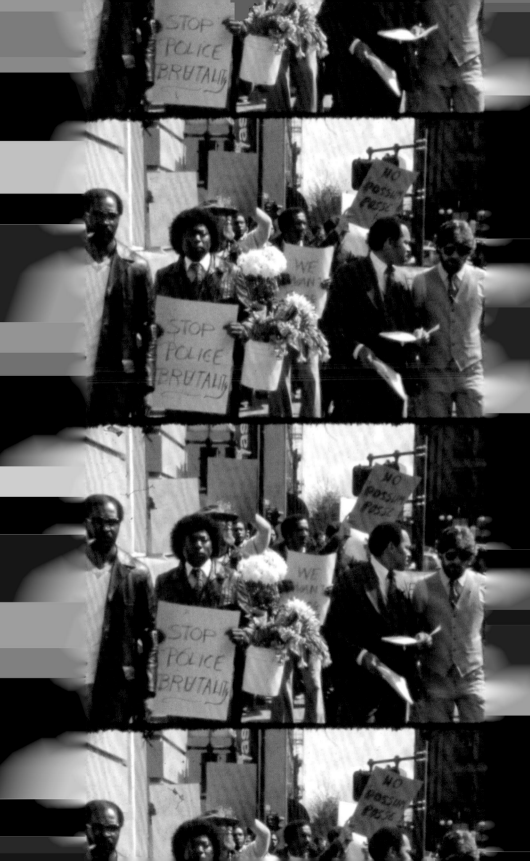

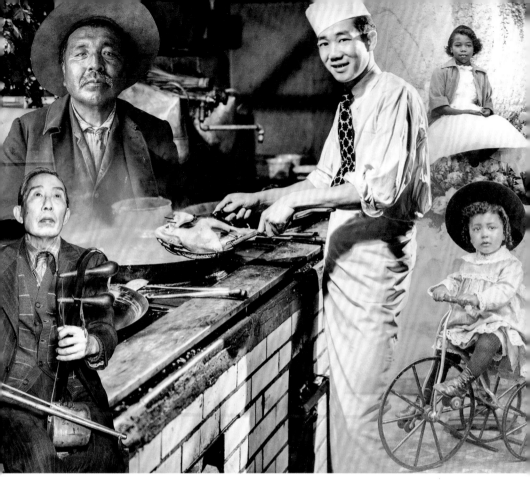

IMMIGRATION IN THE TWENTIETH AND TWENTY-FIRST CENTURIES

Surges of global immigration to Oregon, affected by federal and state laws, changed the state's demographics incrementally, but those changes mark what is likely a permanent trend. In 2020, over 13 percent of the population was Hispanic or Latino and about 5 percent Asian. During the nineteenth and early twentieth centuries, Oregon reacted to immigration by becoming more restrictive and less tolerant, but many of the state's most abhorrent and unjust anti-citizenship laws have been dismantled as some parts of the state have become more open to nonwhites.

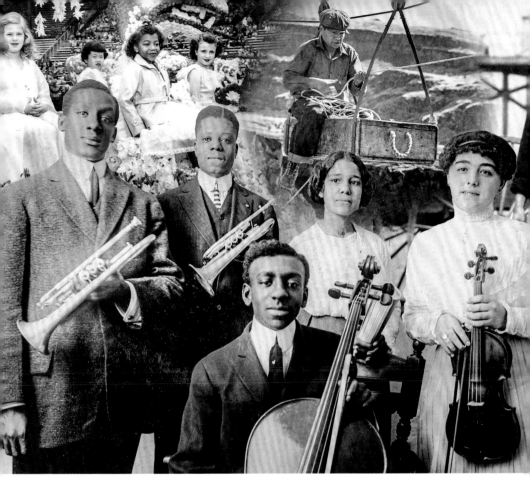

▲ **Experience Oregon mural detail,** 2019. The first image visitors see when entering the *Experience Oregon* exhibit is this mural — composed of images held in OHS's research library collections — of some of the people who represent the places and events that have shaped Oregon. *Image created by The Design Minds for the Oregon Historical Society*

Immigrant communities, in towns such as Nyssa, Talent, Woodburn, and Hillsboro, sustain Oregon economies and challenge systems that have been slow to adapt to a diverse population.

Oregon still has much to do to reach racial equality, but the distance it has come and the progress and change it has made over the last two centuries are the result of the consistent and unwavering will of Oregon's nonwhite communities and their allies.

TAKE A HIGH-TECH WALK THROUGH OREGON

The technology industry arrived in Oregon in 1946, when Tektronix was founded in Washington County. The company, which became the largest post-war employer in the state, spawned other tech companies, many of them clustered along the wooded Sunset Corridor west of Portland, known as the Silicon Forest. Intel opened a plant in Hillsboro in 1976 and remains Oregon's largest tech company, with over 20,000 employees.

Oregon's sports shoe economy can be traced to the success of Bill Bowerman's track-and-field program at the University of Oregon in Eugene. Bowerman, who trained Olympic athletes, partnered with former athlete-turned-businessman Phil Knight to design running shoes. Together, they introduced Nike in 1972, making Oregon a magnet for sportswear design talent and enticing Under Armour and Germany-based adidas to locate their headquarters in Portland.

▲ **Athletic shoes,** ca. 1974.
These nylon and suede Nike running shoes feature innovative Waffle Trainer soles.
OHS Museum, 79-113.1.1,.2,
photograph by Scott Rook

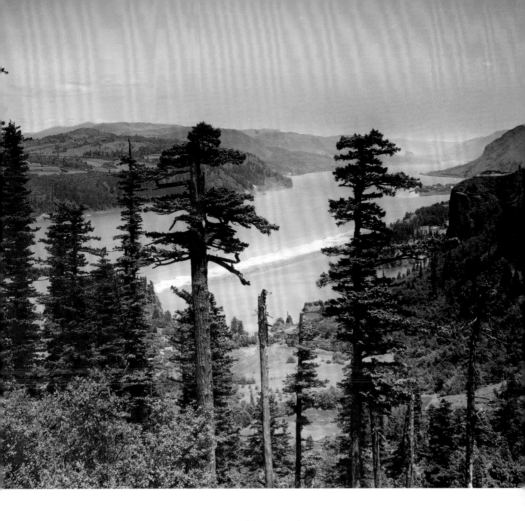

▲ **Columbia River Gorge as seen from Chanticleer Inn,** n.d. *OHS Research Library, John Yeon Collection, box 5, no. 48*

In the twenty-first century, the mining, wood products, and fishing industries have declined in Oregon due to resource depletion, climate change, and advancements in high tech and leisure. Economic shifts in tourism and recreation have made necessary a legislative agenda focused on the environment and the regulation of private property to protect public spaces.

TRIBAL SOVEREIGNTY

The history of the State of Oregon is short. The history of people in this place is much longer. A non-Native Oregonian can claim, at most, eight generations — Native Oregonians claim hundreds. Early white settlers predicted that Natives would fade away and disappear from Oregon. They were wrong.

The federal government again targeted Oregon tribes in 1954 with Public Laws 587 and 588, known as Termination, which ended the trust relationships established by treaties. Members of sixty-three Oregon tribes and bands endured the deleterious effects of Termination, including the loss of their land. Beginning in 1975, some Oregon tribes gained back their sovereign and land trust rights with Restoration acts, the result of years of advocacy in partnership with state leaders.

▲ **Flags of the nine federally recognized tribes in Oregon**, on display in *Experience Oregon*. From left to right: Cow Creek Band of Umpqua Tribe of Indians; Confederated Tribes of Coos, Lower Umpqua and Siuslaw Indians; Confederated Tribes of Grand Ronde; Coquille Indian Tribe; Confederated Tribes of Warm Springs; Confederated Tribes of the Umatilla Indian Reservation; Confederated Tribes of Siletz Indians; Burns Paiute Tribe; and Klamath Tribes. *Photograph by Andie Petkus*

The State of Oregon recognizes nine tribes as sovereign nations — a result of treaties negotiated during the nineteenth century, which consolidated hundreds of bands onto reservations. The U.S. government cut away at reservation boundaries, by treaty and through federal laws, well into the twentieth century until reservations were a fraction of their original size. Many tribes have purchased or negotiated for lost land, an effort that continues today. Other Oregon tribes, such as the Chinook and the Clatsop-Nehalem, still fight for federal recognition.

In some ways, Oregonians have been asking the same questions for almost 200 years: what is the land for and who is the land for? That ongoing tension is as much a part of Oregon's narrative as that of endurance and grit, and the more we know about how Oregonians have answered those questions in the past, the better able we are to address them in the present.

Notes:

Page 21
"Scenes of Romantick Grandeur" is a quote from Patrick Gass's *A journal of the voyages and travels of the corps of discovery* (Philadelphia: Matthew Carey, 1812).

Page 39
"Golden Horn of Plenty" is taken from a 1907 booster campaign by the Commercial Club of Elgin, Oregon. OHS Research Library, Mss 6000.

Page 48
"Get Oregon out of the Mud" was the Oregon Highway Commission's rallying cry, later motto, created in 1913.

Text and photography © 2021 Oregon Historical Society

Book © 2021 Scala Arts Publishers, Inc.

First published in 2021 by
Scala Arts Publishers, Inc.
c/o CohnReznick LLP
1301 Avenue of the Americas
10th floor
New York, NY 10019
www.scalapublishers.com
Scala – New York – London

Distributed outside of the Oregon Historical Society in the book trade by
ACC Art Books
6 West 18th Street
Suite 4B
New York, NY 10011

ISBN 978-1-78551-276-6
Library of Congress Control Number: 2021915948.

Amy E. Platt is project manager, contributor, and editor for the Oregon Historical Society's digital history projects. Erin E. Brasell is managing editor of the *Oregon Historical Quarterly*, the Oregon Historical Society's scholarly journal. Robert Warren is OHS's digital services photographer.

This catalog was initiated and realized because of the enthusiasm and dedication of Oregon Historical Society staff. Without their combined decades of knowledge, stewardship, researching, writing, and publishing, the exhibition and this work would not have been possible. The Oregon Historical Society would like to extend special thanks to Kim Buergel, Eliza E. Canty-Jones, Tara Cole, Matthew Cowan, Laura Cray, Helen Fedchak, Shawna Gandy, William L. Lang, David G. Lewis (Grand Ronde and OSU Anthropology and Ethnic Studies), Helen B Louise, Rachel Randles, Debora Sanberg, Andrew VanDerZanden, and Nicole Yasuhara. Their work and expertise have been invaluable.

10 9 8 7 6 5 4 3 2 1